Images of Modern America

MAITLAND ART CENTER
ANDRÉ SMITH AND THE RESEARCH STUDIO

T0414075

Over 65 artists lived and worked at the Research Studio from its founding in 1937 until André Smith's death in 1959. This painting by Smith shows an idyllic day in the Studio Court, which was the area where the artists kept their quarters (*Untitled [Courtyard Scene]*, undated, oil on board). Today, Smith's legacy is kept alive through the center's artist residency programs. (Courtesy of the Archives of the Art & History Museums of Maitland.)

Images of Modern America

MAITLAND ART CENTER

ANDRÉ SMITH AND THE RESEARCH STUDIO

DANIELLE THOMAS AND
THE ART & HISTORY MUSEUMS OF MAITLAND

ARCADIA
PUBLISHING

Published by Arcadia Publishing
Charleston, South Carolina

Printed in the United States of America

Library of Congress Control Number: 2023947479

For all general information, please contact Arcadia Publishing:
Telephone 843-853-2070
Fax 843-853-0044
E-mail sales@arcadiapublishing.com
For customer service and orders:
Toll-Free 1-888-313-2665

Visit us on the Internet at www.arcadiapublishing.com

This work is dedicated to the "Trio Espero"–André Smith, Duke Banca, and Florence Banca–and their dear friend Mary Curtis Bok.

CONTENTS

ACKNOWLEDGMENTS

This book was made possible through the research efforts of the staff and volunteers at the Art & History Museums of Maitland. Exhibitions manager Katie Benson and historian Elizabeth Herman have played pivotal roles in expanding our knowledge of Smith through both their rigorous research efforts and their commitment to preserving Smith's legacy. The research done by Christine Madrid French for the site's National Historic Landmark nomination also provided a foundation of knowledge for André Smith's story that we continue to build upon today.

I want to give a very special thank you to Peter Banca, who has generously shared his memories of André Smith. His oral histories have provided valuable insight into Smith as a person and the rich life that Smith shared with the Banca family both in Connecticut and Florida. I also want to thank the Curtis Institute of Music for sharing the letters of André Smith and Mary Bok held in their archives, which has changed the way we understand Smith's story, his friendships, and the founding of the Research Studio.

Unless otherwise noted, all images in this book are from the archives of the Art & History Museums of Maitland, including color slides that were taken by Duke Banca between 1937 and 1962 and later donated to the center by the Banca family. Other images are courtesy of Jeni Bassett Leemis, Roberto Gonzalez, Dan Hess, Jim Hobart, Olin Library at Rollins College, Daniela Ortiz, and Willoughby Wallace Memorial Library.

INTRODUCTION

Smith belonged to a generation of restless giants. Hemingway, Eliot, Frank Lloyd Wright, the Ash Can School were his contemporaries. Born before the turn of the century, they fought a war, expatriated themselves in protest against the rise of Babbitism in post war America and created for us the models by which all future American art must be studied.

—Robert Eginton, 1974

When thinking of Florida, one must think of contrasts: of rough interior terrain leading to smooth Gulf waters; of unyielding August heat and grove-killing freezes; of highways that stretch between bustling theme parks to backroad swamp towns. It is a state of hard beauty, and it requires a certain amount of resilience to live here. Perhaps no other Florida artist better embodies the spirit of the state, with its resilience and its tough, bright beauty, than Jules André Smith.

Smith was himself a study in contrasts. He was born into privilege, studied architecture at Cornell University, and achieved early acclaim as an etcher, even winning a gold medal at the Panama-Pacific International Exposition in San Francisco in 1915. At the end of his life, he found his artistic inspiration in the weathered communities of Florida's sandy pine country, choosing grove workers as his companions and concrete as his favored medium because of its affordability. The change between these two lifestyles can be traced to a pivotal moment in Smith's life—the amputation of his leg in the 1920s, the result of an injury suffered in his military service during World War I.

Smith was bedridden for a year and would be affected by phantom pain throughout the rest of his life, but it was also in his recovery that he felt he "rose from the dead," and "things he always want to do and never dared to do, he now did." It is at this time that Smith began the latter half of his life's work, which would be marked by fervent experimentation. He began exploring with abstraction, color, and different mediums, creating solely for the sake of creating and experimenting solely for the sake of experimenting. He became, in essence, an artist's artist, living in the moment of expression.

Smith made his way to Florida in the late 1920s, first traveling in the winters and then eventually buying property in Maitland. Though he had the means to settle and have a prosperous career in any part of the country, he was drawn to Central Florida's small dusty grove towns. He wrote lovingly about the area:

> I had chosen the center of the state, the Inland Lake Country, in which to settle and build my studio. This was the little town of Maitland, with grown-up cities such as Orlando within easy reach. The buzzing highway—U.S. 17—cut through the rustic edge of our little town without even seeing us. I built my studio in an orange grove, and I bought the land for the sunset.

Smith's work became heavily influenced by the natural and cultural landscapes of Florida, and it was in 1937, at the age of 57, that Smith would create his greatest life's work within the interior of the state: The Research Studio—today known as the Maitland Art Center—a winding, concrete and stucco compound dedicated as a winter artist's retreat, built solely for the purpose of fostering artistic exploration. The buildings, adorned with over 2,500 hand-carved concrete reliefs and sculptures, are reminiscent of Smith's surrealist works, which depict crumbling ruins and ethereal fantasy landscapes. But unlike those paintings, the Research Studio is a living work of art, one that invites the viewer to exist within it, to work within it, and to create within it.

Over 65 prominent artists lived and worked at the site until Smith's death in 1959, and in 2014, the Maitland Art Center received national acclaim with the prestigious National Historical Landmark designation for its unique design. The site's fantasy architecture, classified as Mayan Revival, is a blend of Art Deco motifs, religious imagery, and entities sprung from Smith's fertile imagination; Christian symbols appear alongside Buddhist figures as well as a fantastical slate of warriors and deities inspired by ancient Mesoamerican iconography.

Smith holds an important place in the development of Florida's cultural landscape. According to Smith, when the Research Studio gallery was established, it was one of only three formal galleries in the entire state, and it was the first in the state to be dedicated to the new modern art movement. Smith waged a war in the local newspapers for the acceptance of new artistic expressions and constantly encouraged the artists at the center to become more experimental in their practices. He also rigorously forced himself to push his own boundaries, seeking to fulfill the bold statement he once proposed as the guiding motto of the Research Studio: "As artists we must rise above ourselves since only as the instrument of God can we proclaim the deeper visions of the Soul."

Even as the art community in Central Florida blossomed, as the public embraced modern and surrealist artwork, and as galleries and museums sprang up across the state, Smith remained committed to his singular, unwavering vision for the Research Studio, that it act as a haven for artists to work without restrictions or creative boundaries. Smith's legacy lives on today at the Art & History Museums of Maitland through its artist residency programs, contemporary exhibitions, and the preservation of the historical site. And just as they did during Smith's lifetime, artists continue to work in the studios—studios steeped in decades of expression, the layers of paint on the floors and walls holding the stories of those who came before, those who dared to break from expectations and, with brush in hand, dream.

And sometimes, the lucky ones, report feeling Smith, that restless giant, watching over their shoulder.

One

FINDING ESPERO

Jules André Smith was born in Hong Kong on December 31, 1880, to Elizabeth Conner and John Henry Smith, a ship's captain who worked in the export business. The family relocated to Germany in 1887, and when John Smith died suddenly at sea, Elizabeth Conner moved with her children to Boston and then later settled the family in New York. These early years, both in the scope of their cultural influence as well as in the fortitude they would have demanded, provided André Smith with a foundation for a life that would later be colored by creative freedom and rugged determination.

Smith's love for art emerged at an early age, but "fearing he might become an artist," his parents encouraged him to instead pursue architecture. Smith attended Cornell University and excelled in his studies, receiving a bachelor of architecture in 1903 and a master of architecture in 1904. He was awarded a two-year traveling fellowship from 1904 to 1906, which was spent traveling throughout Europe. These trips "awoke in him an art-longing," and it was not long before Smith was gripped with a renewed determination to become an artist. He taught himself how to etch, an exacting discipline in which his training as an architect gave him an advantage, and in 1908, he created his first etching plate. His frequent trips to Europe with his friend and fellow etcher Ernest Roth provided him with picturesque subject matter as he refined his skills. Shown here is one of his earliest works (*Maryland Casualty Co. Building*, c. 1912, etching on paper).

Smith embraced an experimental spirit in his work, stating in a letter to Ernest Roth, "I am . . . trying to do things that no sane etcher would attempt. At any rate they interest me, are distinctly American and if the time and copper are wasted it's not the first time it's happened." His reputation as an artist quickly grew, and in 1913, H.H. Tolerton remarked, "He would indeed be a bold critic who ventured to say that Mr. Smith will not be, in the near future, among our most distinguished painter-etchers." In 1915, Smith was awarded a gold medal in etching at the Panama-Pacific International Exposition, which featured over 2,000 etchings submitted by the most prominent etchers of the time. This was a remarkable accomplishment for someone who had only taught themselves the discipline seven years prior. Pictured here is a work that was exhibited in the exposition (*Campo Fosca*, 1914, etching on paper).

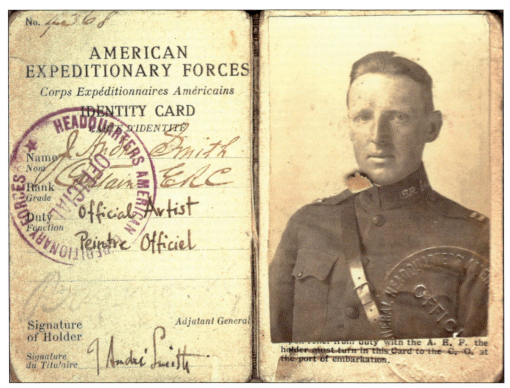

When the United States entered World War I, Smith set aside his architectural practice and patriotically volunteered for duty. He completed officer training at Plattsburgh Training Camp in New York and was commissioned as first lieutenant in the Corps of Engineers in Washington, DC, in September 1917. The unit, which would unofficially become known as the American Camouflage Corps, was devoted to developing new methods of concealment. Many of his fellow camoufleurs were also architects, along with artists, carpenters, and set designers, whose knowledge of design and fabrication made them ideal candidates to experiment with the textures, forms, and color palettes needed for the work. Smith wrote about their experiments in "Notes on Camouflage" in the *Architectural Record*, noting, "There is a super-hellishness about modern warfare that is almost beyond our wildest imaginings, and the act of defense and offense has called forth every means, every device and every art to serve as a shield and weapon against its frightfulness." The image below shows an etching by Smith that illustrates the utter destruction wrought by the war (*Road to Thiaucourt*, 1919, etching on paper).

André Smith was promoted to captain in the Corps of Engineers in February 1918 and was the first of eight artists sent to France to record the activities of the American Expeditionary Forces. The artists were stationed north of the American headquarters in Chaumont. They had clearance to travel freely and documented the daily routines of the soldiers embedded along the front lines as well as those toiling in support roles. His images provided a panoramic view of the great movements of men and machinery that acted as a backdrop to the war, and while never in battle, the artists were often among the first on the scene to record the aftermath. Smith was by far the most prolific of the artists and, by January 1919, had finished almost 200 works. Pictured are two untitled works completed during this time period (Above, charcoal on paper; right, watercolor on paper.)

André Smith remained in France until March 1919 and, after his discharge, published *In France with the American Expeditionary Forces*, a collection of his illustrations and observations of the war. In the foreword, he writes, "When a war poses for its picture, it leaves to the artist the selection of the attitude in which the artist may desire to draw it. . . . War posed for me in the attitude of a very deliberate worker who goes about his task of fighting in a methodical and thorough manner. If the picture of war which the sum total of my drawings shows has any virtue of truth or novelty it is in this respect: it shows War, the businessman, instead of War, the warrior. It is an unsensational record of things actually seen, and in almost every instance drawn, as the saying is, 'on the spot.' " Pictured above is a work from this period (*Nieuport*, 1919, conté crayon and gouache on paper). At left is a photograph of Smith in the field with some of his fellow American Expeditionary Forces (AEF) artists.

In a particularly moving passage from the book, Smith writes, "Hardly ten feet from where I stood was a group of apple trees in full splendor of pink blossoms, and except for a gash of raw dirt and mud that marked the subterranean passage to a cave through whose narrow, horizontal window a gun pointed to the enemy, the grass about me was a mat of soft lusciousness. In a nearby field a man could be seen plowing. Against the setting of pastoral beauty it was difficult to account for the line of shattered trees and fallen branches that marked the position of our batteries and the enemy's efforts to silence them. . . . Here was a picture of war that was not for a warrior but for a poet . . . a poet in a 'tin hat.' " Pictured here is *At Chartreves*, 1919, etching on paper. A signed proof of the etching was included in each copy of the book.

15

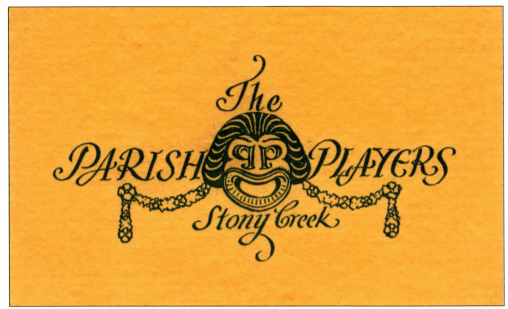

On April 19, 1919, André Smith was discharged from the Army and returned home to Branford, Connecticut, where his sister and mother also lived. By this time, he had made a full departure from architect to artist. He continued to travel to Europe with his friend Ernest Roth, sketching and painting pastoral landscapes and cobblestone European towns. His etchings were regularly shown in galleries in New York, and during this period, he found another outlet for his creative urges. Smith began designing stage sets for the Parish Players, a local theater group in the neighboring bohemian seaside village of Stony Creek. It was the perfect merging of his talents as an artist and architect, and he wrote several plays during this time. Pictured above is a logo for the Parish Players that Smith designed, and pictured below is an ornamental concrete grill that Smith would eventually sculpt for the Research Studio, inspired by his theater work (Above, courtesy of the Willoughby Wallace Memorial Library; below, by Danielle Thomas.)

In 1924, André Smith became bedridden with a serious illness that would profoundly alter the trajectory of his life and his work. He underwent a year-long series of surgeries relating to an old injury caused by barbed wire during basic training, culminating with the amputation of his right leg. He would suffer from phantom pain for the rest of his life. His mother, who had moved in with him to care for him during his illness, died during his recovery. It was a period of intense darkness for Smith, but as he emerged from it, he created the work pictured above (*Espero*, 1926, etching on paper). The work was published in the *Architectural Record* along with several other images of a fantasy European town of Smith's invention, with him writing, "Behold the city of Espero! But do not bother to search for it . . . in maps because you will not find it there. It is a city of hope, a place that you are always looking for and yet never find . . . completely."

As he recovered from his long illness, André Smith immersed himself in his artwork and continued his work in set design with the Parish Players. In 1926, he met Attilio "Duke" Banca, a young man from Stony Creek who he initially hired as his chauffeur, now being unable to drive himself. The relationship quickly grew into an enduring friendship, with Banca later recalling, "We shook hands and we stayed together for the rest of his life. I did everything with him. I was his secretary, companion, chauffeur, everything. He thought that he couldn't breathe without me." Smith began traveling to Europe during the winters, first with his sister, Augusta Johannes, and later with Duke Banca and Smith's old friend Ernest Roth. Pictured above are Smith (left) and Roth (right) in France in the 1920s, and below is a European scene dating to this period (*Untitled [Golden Square]*, undated, oil on Masonite).

André Smith and Duke Banca eventually moved in together, and Smith later built a home for them to share on Banca's property in Stony Creek. In reflecting back on this period, Smith wrote biographically of himself, "After the War came a long period of serious illness, from which he recovered or, as he expresses it, "rose from the dead" with fresh determination and especially with a clear revaluation of time and freedom. . . . Things he always wanted to do and never dared do, he now did." Smith was entering a new phase in his life, one that would be marked by fervent experimentation. He continued to create more traditional works inspired by his European travels, such as the one pictured here (*The Witch House*, undated, oil on Masonite), but also began exploring abstract expressions.

Smith's changing attitude toward his artwork is perfectly summed up in a description he wrote of an exhibition of 55 paintings shown in 1928 at Cornell University's Morse Hall Gallery: "First of all, there are the straight representational pictures; things seen and recorded visually. These are my lazy offerings. Most of them were done in pleasant sunshine, the air charged with the fragrance of flowers, the day entirely too lovely, or myself too well at rest with the world to do, take, or ask for more than was before me. In the second class. . . . I have used the visual experience merely as a port of embarkation; I have climbed aboard my subject, so to speak, commanded the helm, and let it carry me not where it would but where I wanted to go. I must admit that my destination was not always achieved; too often I let myself drift." Pictured are two views of Carros, France, that show Smith's evolving style (above, *Untitled [French Hill]*, undated, oil on board; below, *Carros*, undated, etching on paper).

Smith continues: "In the third group (of which there are only a few) are the more abstractional paintings. In these I frankly took the air above my subject matter and went in for a few orderly loops and a tailspin. They are efforts to fly in an atmosphere which I still feel is treacherous and unknown to me. . . . However, this is an adventurous age in which people are always started off for somewhere and are never heard of again. It is time of test and experiment. Speed, noise, and sudden crashes. I am glad to be part of it, to contribute to the rush and confusion, and take my share of crashes." The image at right (*Untitled [Stark Segovia]*, undated, etching on paper) shows a view of Segovia, Spain, and the image below (*Untitled [Abstract Female Form]*, undated, etching on paper) is among a series of fully abstract etchings.

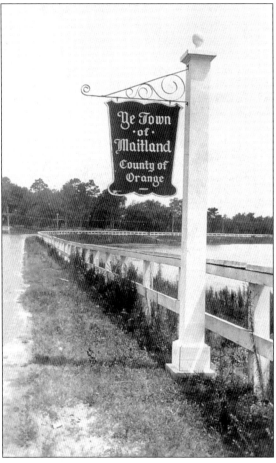

André Smith and Duke Banca began traveling to Florida in the late 1920s. They initially rented a home on Lake Knowles in Winter Park, where they were neighbors to the famous actress Annie Russell, whom Smith worked with on set design. Smith later purchased property in the nearby town of Lake Maitland. Maitland, which, in 1930, had a population of only 889, had once been a thriving hub for citrus as well as a fashionable travel destination for wealthy Northerners, including US presidents Grover Cleveland and Chester A. Arthur. The citrus freeze of 1895 had decimated the local citrus industry, diminishing Lake Maitland's prosperity, and by the 1930s, Winter Park had replaced it as the hub for Central Florida's social scene. Shown here is Stone's Service Station in 1920, a "one-stop service station" on Highway 17-92.

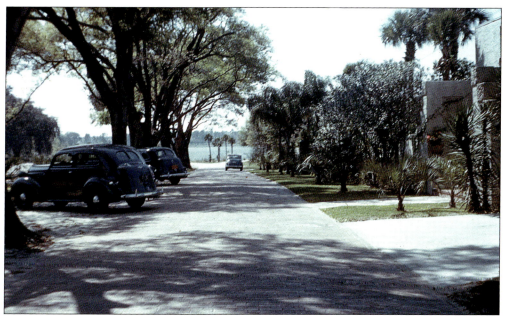

In an article in the *Winter Park Topics* in 1940, André Smith described why he was drawn to Maitland: "In Maitland one is more apt to meet a chicken on the street than a professor. It is this rustic accidentalism that endears me to a place that actually calls itself a town instead of a City and has so far avoided sloganizing itself in the name of the great god Boost. Along with Maitland's rustic overtone is the comforting knowledge that once upon a time it was THE town of Central Florida. But Fate was kind to it, and although progress and development struck like lightning all around the county it did no damage here." Pictured above is a view down Packwood Avenue looking toward Lake Sybelia. Smith initially bought land on the north side of the road. Pictured below is the small house he built in the center of the property.

André Smith and Duke Banca began spending every winter in Florida. Smith became enchanted with the lush, semitropical landscape, and his focus on European imagery was increasingly replaced with images of Florida's dense interior, which he discovered on his sand road treks through "salt meadow, and jungle of cabbage palm." The work pictured shows this influence (*Untitled [Roofs and Palms]*, undated, oil on board). During the summers, Smith and Banca returned to their home in Connecticut, where Smith would resume his theater work. For several summers, he also hosted the Vacation School for Modern Art out of his Stony Creek studio, where students were encouraged to embrace experimental approaches to their artwork and, later, in theater set design. Smith continued to experiment with his own artwork as well, notably in his use of concrete for sculptural work.

Even though André Smith was charmed by Central Florida's tightly knit communities and lush landscape, he became increasingly outspoken against the local art scene, frustrated by what he saw as an unwillingness to embrace or exhibit modern art. In one particularly caustic letter to the *Winter Park Topics* in 1935 following an exhibition of Italian paintings, Smith wrote, "Now that the Kress Collection has come and gone and left upon us a smug afterglow of 14th century art would it be too violent on my part to suggest . . . that immediate steps be taken to bring this cultured corner of Florida an exhibition of modern or modernistic art in order to expel the dank moldiness and residue of antiquity that is so habitual here . . . ? Can't something be done about an awakening of an art-consciousness of the 1935 brand in order to counteract the sweet slumber of a mouldering past?" The painting pictured above shows celery farmers in Sanford, Florida (*Untitled [Harvest Scene]*, undated, oil on board), and the below image shows a couple reclining (*Untitled [Resting]*, undated, oil on board).

Despite André Smith's criticism of Central Florida's cultural scene, he found much of his artistic inspiration during this period in the rural weathered towns and citrus groves that surrounded the area. In a 1952 article published in the *Ford Times*, he wrote, "If some of the houses seem to be leaning from a kind of painless neglect, there is true creative interest in the upkeep of churches. One church which offered me an interesting subject had lost its steeple in a hurricane. This was replaced with a new structure. Since then, with the advent of concrete blocks, I watched what is probably the most unusual alteration I have ever seen. An entire new church was built around the old one, containing it, and when the outer one was completed, the old wooden church was taken down or apart, and, bit by bit, carried out the front door of the new one!" Pictured here is *Church Scene, Eatonville*, undated, oil on Masonite.

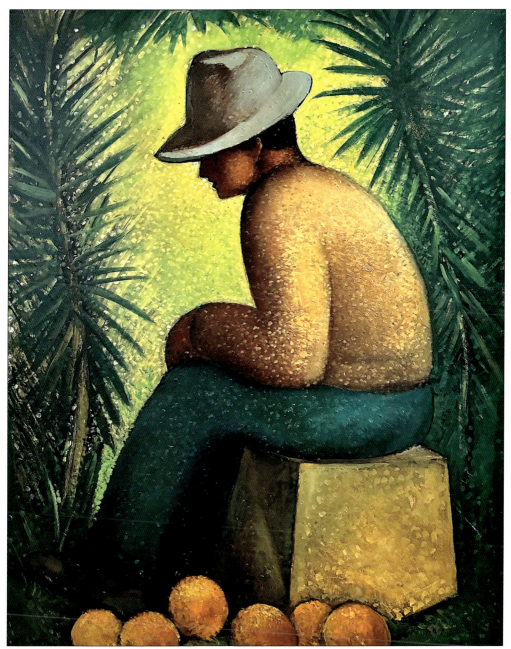

André Smith continued his loving description of the area in the *Ford Times* article, stating, "On byways you watch the orange pickers at work. They swarm into the groves with their ladders and trucks and soon the trees are alive with them. As they move from tree to tree, wearing their colorful sweaters, filling their canvas bags with oranges, they present a picture to warm an artist's heart—or a traveler's. And on the byways the people at home, at rest, living. And for simple loveliness and tranquility you have the sand roads to solitude of huge live oaks and stately pine, with always the silver gray veils of Spanish moss giving motion to the moonlight. These roads lead to the Florida I know. Slow down, and choose one." Seen here is *Untitled (Grove Worker)*, 1936, oil on board.

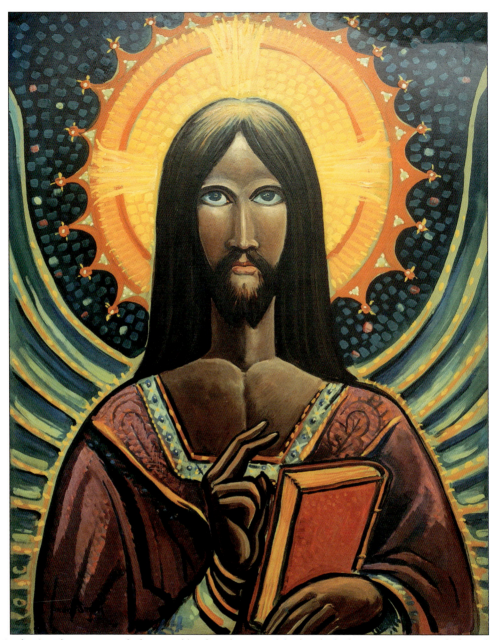

André Smith was particularly moved by the vibrancy of the local Black communities, including the nearby historic all-Black township of Eatonville, where he would frequently sit and sketch on the side of the road. His drawings and paintings often included imagery of spiritual life, and in 1936, he began painting a series of large panels for the New Hope Church in Winter Park. The works included an altarpiece depicting a dark-skinned Man of Sorrows, alongside eight panels based upon Psalm 23. The panels and altarpiece were later removed from the church. The altarpiece was lost, but Smith retrieved the panels and gifted them to the St. Lawrence Church in Eatonville, where they remain today. Rollins College maintains an image of the original altarpiece in its archives, which indicates that the painting pictured was done as a study for it (*Untitled [Christ in Red]*, undated, oil on board).

André Smith provided barbed commentary on race relations in Central Florida in an article in the *Winter Park Topics* in 1936, writing, "The 'American Scene' around Winter Park is clearly divided by the railroad track into two zones: the snow-white and the jet-black. And from the painter's point of view the choice is about even, if anything, I believe the jet-blacks have it a little over the snow-whites. They live in a combination of brightness and contrasting bleakness that is well worth recording . . . and far more impressive than what the snow-white population has to offer." These paintings capture his opposing viewpoints of the two communities. Pictured above is *Church Goers (Eatonville)*, undated, oil on board. Pictured below is *Listening to each other's lectures*, 1936, oil on board.

In the spring of 1936, André Smith produced a series of surrealist watercolors he described as "automatic" drawings, in which he allowed his subconscious mind to guide his pencil and brush, finding himself in the "position of a rather amazed bystander who sees before his eyes happenings that seem to be only vaguely connected with his own volition." He rapidly completed a series of 38 paintings over the course of six weeks, which today are considered to be among his best works. In December 1936, four of the pieces were included in a group exhibition at the Museum of Modern Art called *Fantastic Art, Dada, Surrealism*, which included contemporary works by Picasso, Dali, Magritte, and O'Keefe. Pictured here is *Women Know Where Men Love Best To Roost*, 1936, watercolor on paper.

In 1937, a selection of the works was published in *Art & the Subconscious*. In the foreword, Smith remarks, "We are, I believe, at the beginning of a new phase of art. The wild orgy of color, design and reasonable madness through which we have been moving for the past decade must be leading to a new course that art will have to follow. Our leading creative artists are already conscious of this widening of the stream of art-creation which has at present resulted in a pause, a back-eddying, a few dimpled whirlpools of experimentation and which before long must lead to a rushing waterfall of new and stimulating creativeness." Pictured are two works from the series (above, *And Here is a Toast to Our Memories!*, 1936, watercolor on paper; below, *Never Mind, She Will Get You Yet*, 1936, watercolor on paper).

Smith later wrote short poems to accompany the images, which were added to each volume after publication as a small booklet. The verses, like the artwork, offer a worldview that swings between biting satire to gentler impressions of aspiration and faith. The painting seen here was paired with the following verse (*Why Must You Always Keep on Wanting Things?*, 1936, watercolor on paper): "Why must always keep on wanting things? / The lofty pinnacles of space / The isolated flower of desire / That calls you to an endless chase. / Do you not know the stars are with you / The moon is yours, and every day the sun / Bestows its golden benediction / And blesses you for deeds well done?"

Two

BUILDING THE
RESEARCH STUDIO

In 1936, André Smith forged a powerful friendship that would lead to the creation of his life's greatest work: the Research Studio, today known as the Maitland Art Center. The sprawling artist's compound, seen here in an image included in a Research Studio brochure, would become the physical manifestation of his determination to live a life of untethered creativity.

André Smith met Mary Louise Curtis Bok at the funeral of their mutual friend, actress Annie Russell, in January 1936. Smith, who was known for his biting wit, found a kindred spirit in Mary Bok, who was also known for her puckish humor. Bok was the only child of publishing magnate Cyrus H.K. Curtis and Louisa Knapp Curtis, whose company was famous for launching the *Saturday Evening Post* and the *Ladies' Home Journal.* Mary Bok was well-known for her philanthropy and by this time had already founded the Curtis Institute of Music; built Bok Tower Gardens with her late husband, Edward Bok; and funded the Annie Russell Theater at Rollins College. Bok and Smith quickly became friends. Pictured above are Annie Russell (left) and Mary Bok (right), and below is Bok with André Smith. (Above, courtesy of the Department of College Archives and Special Collections, Olin Library, Rollins College, Winter Park, Florida.)

In October 1936, an offhand remark in a letter from André Smith to Mary Bok would lead to an interesting proposition. Smith, grumbling about rumors that Rollins College was to build a gallery, wrote, "Once, as you know, they had visions of having the Kress Collection handed to them. And I suppose in time this dream of a museum will come true, as well as my prediction that the building will become the depository of the discarded old paintings that the ancient ones have been storing in their cellars and wondering what to do with. . . . But what a chance they are missing down there if they would only let in a little light." Pictured above are blueprints for the gallery that Smith would eventually build, and below is a concrete panel outlining the purpose of the project that Smith and Bok were about to embark on.

Mary Bok was quick to respond to Smith's letter, writing back four days later, "What would you think of securing, if possible, a bit of ground, more or less centrally located, and putting up an inexpensive but sufficiently adequate little Gallery of your own, me helping you to this financially, providing it wouldn't be too expensive? If the idea appeals, let's call it Independence Hall, with not a string running toward the college. Or am I unchristian or all Rong?" Pictured above is a street view of the Research Studio, showing the tall walls that would be built to secure Smith and the other artists' privacy. Below is a view of the garage through the front gates.

André Smith replied immediately to Mary Bok's offer in a telegram, writing, "As soon as I can breathe evenly and think clearly again I will write you regarding your amazing offer." The next day, he wrote a longer letter and outlined his thoughts about what a gallery in Maitland might look like: "I begin to think that the only gallery that might be useful would be one that would be separate and yet adjoining my small 'estate' in Maitland. I could have exhibitions there whenever I could get hold of things especially worthwhile, keep it under my control and if possible make of it a sort of combined club and gallery and provide a meeting place for local artists and those interested in art. In that case I would make the place more like an art-laboratory than an art-gallery; a place where new ideas could be talked over and tried out, the sort of experiments in color, handling and adventuresome expression that as a rule have no chance for encouragement." Pictured is a concrete marker for the Research Studio.

Over the next several months, André Smith and Mary Bok exchanged a flurry of letters as plans for the project unfolded. They agreed to call it the Research Studio Gallery, but the purpose was constantly evolving. In a letter to Bok in November 1936, Smith wrote, "I admit that I still have no clear idea how it will all work out, or in what manner I shall proceed after the gallery is ready for action. All I know is this: that there is an extra creative force to which artists are particularly responsive. . . . In such a mood things just happen, and the artist takes his place in the universe merely as a recorder of the Truth." Pictured above is the entrance to the Main Garden, a lush enclosure of tropical foliage and orange trees that would become the heart of the Research Studio. Smith and Banca's dog Koko is in the foreground. Below is a view of the Main Garden from the west.

As plans for the Research Studio Gallery grew, André Smith's household also expanded. In the fall of 1936, Duke Banca married Florence Lavassa, who like her husband was a native of Stony Creek. She moved in with her husband and Smith. In December 1936, Smith fondly wrote to Mary about the new living arrangements: "This New Deal under the management of Florence has so far proven to be nothing less than a blessing. She has taken charge of our household affairs with easy grace and thoroughness . . . Duke, too, is another boy; his former hither-and-tithering have vanished in his contentment to be with his wife and help her with our home doings." Pictured above is Florence Banca in the Research Studio Main Garden, and below is a close-up of the pond, showing a vase that was a gift from Mary Bok's Green Mountain Estate.

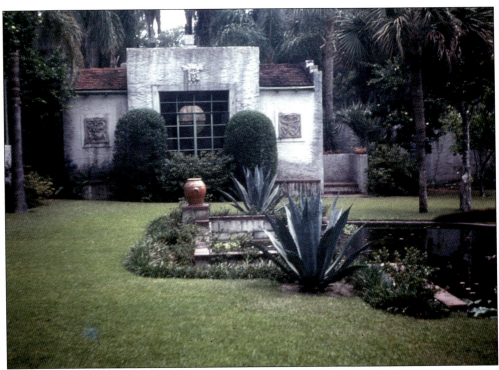

The plans for the Research Studio were officially announced in the *Winter Park Topics* in January 1937. The newspaper noted, "The Winter Park Topics has during its busy lifetime sponsored with considerable interest the stimulating "Battle for Modern Art" that Mr. Andre Smith has so persistently waged here with his amusing and often pointed pen. And it is for this reason that Mrs. Edward Bok's recently announced gift of a "laboratory" Studio to be devoted to research in modern art . . . impresses us as being an exceptional tribute to Mr. Smith as an artist as well as an impressive victory for the cause for which he has so earnestly fought." Pictured above is the Bok studio, built for Mary Bok's visits to the center, and below is a sculpture that Smith affectionately referred to as "Peter Pan."

News of the gallery immediately drew the attention of the cultural elite in the surrounding community, even resulting in an invitation to join the Allied Arts, a local arts organization that had previously denied André Smith membership. Smith was not moved by the new accolades he was receiving and brusquely declined the offer. He later wrote to Mary Bok, "But now and then I have in-growing misgivings about the upishness of my actions, and especially now that through your grand gesture I have suddenly been elevated and set upon some sort of platform of respectability in your name! Must I reform as a result of this; become an upright citizen and as the Director of the Bok Research Studio shed kindness and light, coo rather than cuss?" Pictured above is the entrance to a loggia off the Main Garden. Pictured below are doors in the loggia, painted by Smith.

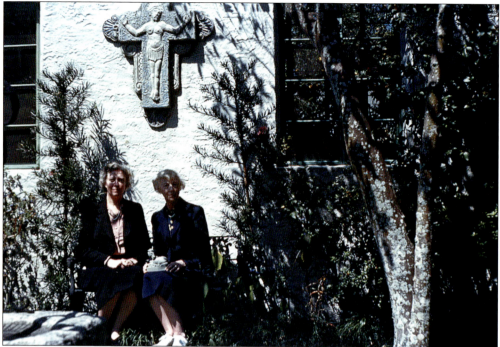

In January 1937, André Smith had a stroke of inspiration that would morph the Research Studio Gallery into something far grander, writing to Mary Bok, "Every now and then as our Art Center rises out of the ground in stark reality of cement and brick, that old U.G. of ours, the Ultimate Goal which we both agreed we shouldn't even think about at present, keeps poking its head above the walls, peeking around the corners at me . . . I can clearly hear him whisper 'What about me; where do I come in on this grand layout?' Of course, I strut past this intruder as if he didn't exist. But between times, and this one of them, his questions assume an importance which I find hard to ignore." He notes that the local artists are unlikely to join him in experimental work and concludes, "I see but one hope for us: IMPORTATION." Both images show the Annie Russell Courtyard, a walled enclosure that André Smith dedicated to the actress. The image above shows Mary Bok (right) in the space with her close friend Edith Evans Braun (left).

Mary Bok readily agreed to André Smith's proposal to make the Research Studio suitable for the "importation" of artists, and plans were quickly expanded to turn the center into a full artist's residency. On February 21, 1937, Smith and the Bancas celebrated the placing of the cornerstone on the gallery tower. Smith writes to Bok ahead of the event, "At noon we will 'serve' beer to the workmen and a cocktail for Heigel & his foreman. All of which seems so simple and fitting compared with the usual blahing, humming and hawing and speeching. I am sure you will approve of this lovely gesture." Smith describes the cornerstone as "bearing the mystic and significant 1937–10-10–3x7–21; 17 the age of awakening–93 the long life of usefulness, etc." and notes that it contains a time capsule of sorts, with blueprints, news clippings, and monograms for the "Banca kids" and Koko, their beloved Chow Chow. Pictured at right is a view of the gallery tower, and below is a guest in front of a mural in the Annie Russel Courtyard.

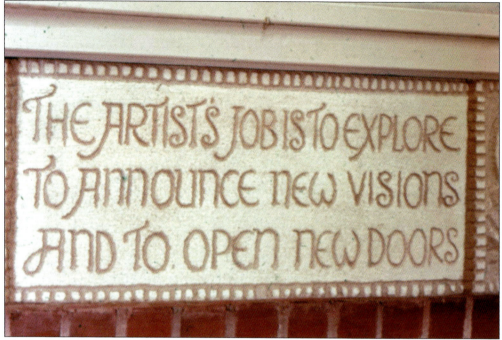

The "Laboratory Gallery," as André Smith called it, could be entered through the Annie Russell Courtyard and contained two galleries and Smith's office. It was designed as a research space, where artists could display and openly discuss their latest efforts. In February 1937, Smith wrote a review of a local play in the *Winter Park Topics* that reflected his desire to see artwork critically discussed: "Art thrives best through challenge and battle. . . . We must either keep on kidding ourselves that we are a culturful bunch of amazing geniuses performing miracles of creative perfection, or let down our encircling walls of radiant illusion, stand out in the open and have the courage and good sense to tell and hear the truth about our offerings. . . . Art gets nowhere at all on perfumed flattery." Above is an inscription over the gallery's fireplace that would act as the unofficial motto for the Research Studio, and below is a view into the front gallery.

The Laboratory Gallery (pictured above) was a long room with partitioned compartments on one side and seating on the other. The compartments were meant to each house a single artwork, which would be lit and viewed separately from the other pieces. Smith's purpose in this design was to allow the viewer to consider each piece independently from the others, and in an article in the *Winter Park Topics*, Smith notes he was inspired by "the most popular and oldest show-places in the world: the zoos and aquariums, in which exhibits are separated, concentrated and entertainingly presented." The gallery was not intended to be open to the public, but rather to act as a resource for the artists in their experimental work. Guests to the exhibitions would be allowed by invitation only. Pictured at right is Smith's office, which adjoined the main gallery.

The first meeting of the Research Studio Board of Directors was held in October 1937, and four of the directors—André Smith, Mary Bok, Duke Banca, and Florence Banca—were present. The charter outlined the official mission of the Research Studio as being "to promote the growth of American art and knowledge and education in art; to that end to provide studios, workshops, galleries, exhibition rooms, living quarters and sustenance, and facilities for research and experimentation in art." Pictured above is a walkway that was nicknamed the "Bean Pot" because it led to the refectory where the artists would be served communal meals. The image below shows Florence Banca in the Studio Court, where the artist studios were located, and which acted as the creative hub of the center.

André Smith provided the visiting artists with an introductory booklet titled "Upon Entering Espero." In it, he writes, "Espero is the name that we have given the small wall-protected enclosure which for the next four months will be your residence and workplace. . . . Here in Espero the 'sky is the limit' in all efforts towards our expression. And so, instead of spending the winter making safe investments and sure-sellers, I would rather have you travel a more exciting route, and let yourself move without fear of criticism along the lanes of new thoughts and ideas. And from time to time it would be helpful for you to crash all barriers and see what you can bring to light." Pictured above is a view of the Studio Court with a sculpture studio in the background that later burned down. The image below shows Mary Bok (left) and Florence Banca (right) enjoying the Studio Court lawn.

The Studio Court originally included studio space for five artists. Artist Elizabeth Sparhawk-Jones, who completed six residencies at the center, recalled in a 1964 interview that "it was a very beautiful place, beautifully planted and the buildings in it were charming, there was only about an acre and a half but it seemed like three times that because it was so placed." She continued, "And they fed us too, delicious food, crab croquettes, alligator pears all under the blooming orange trees in the courts." The image above shows a bell tower above one of the studios, which contains a bell bearing the initials M.B., A.R., and A.S. for Mary Bok, Annie Russell, and André Smith. The bell was a gift from Bok, made by John Taylor in Loughborough, England. The image below shows artist John Hawkins working in front of one of the studios.

André Smith, often a reclusive man, considered the privacy of the artists as being essential to their work. The walled-in, monastery-like enclosure was designed to provide spaces for quiet contemplation, and each studio was equipped with an awning shade that the artists could lower when they did not want to be disturbed. The artists were responsible for maintaining their own studio space, or as Smith put it in his welcoming brochure, "And remember that you make your own bed and lie in whatever you make. If you don't like the combination, you must talk to yourself about it." The image at right shows Smith in front of a studio that was entered through a small loggia. The walls were painted with the assistance of George Marinko, an artist who stayed at the site during its inaugural season. The photograph below shows a close-up of the whimsical mural. (Below, photograph by Danielle Thomas.)

The design of the Research Studio is one of Smith's greatest artistic accomplishments. By the end of his life, the buildings would be adorned with over 2,500 hand-carved concrete sculptures and reliefs, bringing to life the fantasy landscapes that filled his sketchbooks. The sculptural pieces reflect Smith's diverse worldview, with Christian, Buddhist, and Mesoamerican-inspired imagery blending against a fantasy backdrop. Smith described his inspiration in a letter to Mary Bok, writing that some of the pieces were "suggestive of the Aztec carvings for which I have had a lifelong love, dating back to my early schooldays in New York when I used to go to the Museum of Natural History and spend most of my time in the basement where those carvings used to be, and still are for all I know. They did something to me, just what I don't know, something that has stuck and has been a sort of subconscious influence." Pictured above is a page from one of Smith's sketchbooks, and at left is a sculpture located at the Smith and Banca home in Stony Creek.

André Smith developed his own process for creating concrete sculpture. In his earliest pieces, he would build up the concrete directly on the blocks, which resulted in the works having a soupy texture. In his later works, he used a device of his own invention he called a "teeter-table," which was a frame that the concrete would be poured into. Once set, the table could be titled to 45 degrees, allowing for easy carving directly into the block. In a 1940 article in *American Artist*, Smith notes that a grapefruit knife was among his favorite carving tools, and his concrete "recipe" was "as simple as this: take two parts of clear, white sand and one of cement, mix well, add a little water and . . . serve." Pictured above is a sculptural piece created at the Research Studio, and at right is an earlier painting of a fantasy landscape, showing that the world Smith eventually created at the Research Studio had existed in the landscape of his imagination for several years (*Untitled*, 1926, oil on board).

Much of the sculptural work at the Research Studio was originally painted in vibrant colors. André Smith used Alabastine, which was a powdered mineral paint made from gypsum. The powder would be mixed with water and was similar to plaster when applied, making it ideal for relief work and raised decorative motifs. There are only a few areas at the center where the original color remains today. Seen above is a photograph of a sculptural piece adjacent to the Studio Court, and below is a 1962 image of a brightly painted building off the Main Garden that served at different times as an office, a library, and a playroom.

Three

AN INSANITORIUM OF ART

Webster Besedick Galloway + wife Wilma Wolfs Trio Espero Hawkins

Over 65 Bok Fellow artists lived and worked at the Research Studio during André Smith's lifetime. These would be the site's golden years, where Smith continually encouraged the artists to "go wild" and expand their artistic practices with an adventurous and experimental spirit. Pictured are artists from the 1940–1941 season: Hutton Webster, Frank Besedick, Crozier Galloway and wife, Wilma Wolfs, the "Trio Espero" (André Smith and Duke and Florence Banca), and John Hawkins.

Swanson Wolfs Besedick Galloways Hawkins

On the evening of December 31, 1937, each member of the newly founded artist's community took turns ringing the bell in the Studio Court, officially ushering in the Research Studio's inaugural season. Over the next 20 years, André Smith would mentor, encourage, and sometimes grumble at a rotating selection of artists, with the hope of expanding the boundaries of American art. In a 1939 article for *Art Instruction* magazine, he wrote, "I have always felt that the various 'isms' that have come to us from Europe should have been born right here out of the restless, inquiring minds of our own painters. The searching and inventiveness is an American trait. It has been demonstrated in music and in architecture, and in these two fields of art we have reflected our true American spirit. Here we have been ourselves, whereas in art we have merely lagged behind European leaders. What has become of our 'battle cry of freedom?' " Pictured above around 1940 are, from left to right, artists David Swanson, Wilma Wolfs, Frank Besedick, Crozier Galloway and wife, and John Hawkins. Pictured below is John Hawkins working in the Studio Court.

Exhibition
March 31st
to April 15th

This will be the last show of the Season. Please let me know as soon as you can what and how many pictures you will be able to hang on the line. .AS.

A chesty young artists said "Hell,
My paintings are perfectly swell,
The more that I sweat the better they get
And yet the damnthings never sell!"

The artists were encouraged to produce work that could be shown in the Laboratory Gallery during the run of the season. The modern artworks would receive mixed reactions, with one shocked visitor referring to the Research Studio as an "Insanitorium of Art." Smith embraced the term, writing, "Not long ago, some wit called the Research Studio an 'Insanitorium of Art' and I thought it a very excellent designation. However, our 'insanity' is a reasonable one, and our often strange behavior is deliberately assumed in order to obtain definite results. We are overflowing with curiosity, and if somebody in our group asks 'What would it look like if we did so and so?' we talk it over and then get busy and find out. Ours is the wide-open mind with gusts of ideas blowing through it and demanding manifestation." Smith's scrapbooks provide a colorful view of life at the Research Studio. Pictured above is a flyer created by Smith in 1940 encouraging the artists to submit their artwork for display.

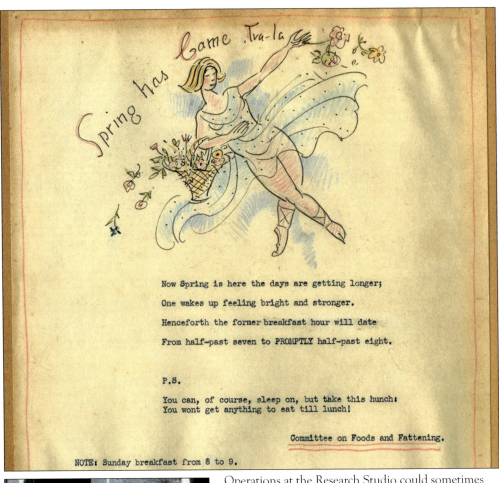

Spring has Came Tra-la

Now Spring is here the days are getting longer;

One wakes up feeling bright and stronger.

Henceforth the former breakfast hour will date

From half—past seven to PROMPTLY half—past eight.

P.S.

You can, of course, sleep on, but take this hunch:
You wont get anything to eat till lunch!

Committee on Foods and Fattening.

NOTE: Sunday breakfast from 8 to 9.

Operations at the Research Studio could sometimes be tumultuous and were particularly so during its inaugural season. André Smith and the Bancas made every effort to attend to the artists' needs and comfort, but it was not long before Smith became frustrated with artists' apparent lack of appreciation. After closing the first season a month early, Smith wrote in the board minutes, "After having accepted with seeming appreciation the charm, comfort and efficiency of their studios and their surroundings in general, they soon began making demands for additional help and money and supplies, and it was not long before they began expressing their dissatisfaction of what we had to offer them as well as our supervision . . . it was a clearly organized effort on the part of two of the group and it was done with the idea of getting all they could out of us. (We found out later that both of these men were active communists.)" The above image is a flyer created by Smith in 1940 announcing a change in meal time, and the image at left shows two guests dining on the "Bean Pot" patio.

André Smith was pleased with the work and congeniality of the second season of artists, but in the third season, he again became frustrated. One artist arrived drunk and had to immediately be sent home, and another was asked to leave because he refused to participate in experimental projects. In the board minutes, Smith wrote, "Although I have tried to make it clear in our printed folders, publicity and Letters that the Research Studio is a place for experimentation in the Fine Arts, I soon found, as I had previous years, that the artists assumed that all their work was experimental and for that reason they made no effort toward a deliberate change in method of working or point of view other than their habitual one." Pictured above are artists from the second season enjoying a meal in the Studio Court (sculptor Bill McVey is at far left, André Smith is at far right). Below is a 1940 flyer from Smith's scrapbook announcing Thanksgiving dinner.

THURSDAY
NOVEMBER 28TH
AT ONE PM.
(cocktails at 12.30)

THANKSGIVING DINNER, OUTDOORS IN STUDIO COURT

ART

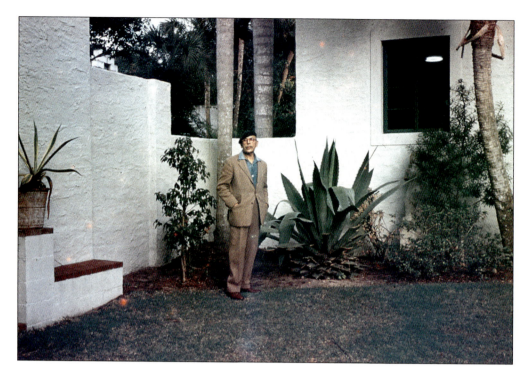

During the Research Studio's fourth season, André Smith stopped directly selecting the artists through personal invitation and instead created an open application process. He was pleased with the quality of the artists, noting in the board minutes, "I am now thoroughly convinced that the invited artist is more inclined to be a troublesome one on the score of a false valuation of himself because of his selection by us, whereas the artist receiving the award in open competition with others will value it more and prove a better worker and fellow resident." Pictured above is a guest in the Main Garden, and below is a page from Smith's scrapbook teasing artist Hutton Webster, who stayed at the Research Studio during its fourth season.

Forgive me, Hut, if I intrúde
With my own version of a nude;
The female form divinely crude,
Piccassoesque and slightly stewed.

Although your nudes are smooth, correct,
While mine are rough and slightly wrecked,
Between us anyone should see
Just how a naked gal should be.

To Hutton Webster

CARVED CEMENT WORK AT RESEARCH STUDIO

At the Research Studio in Maitland a new doorway in carved ce-

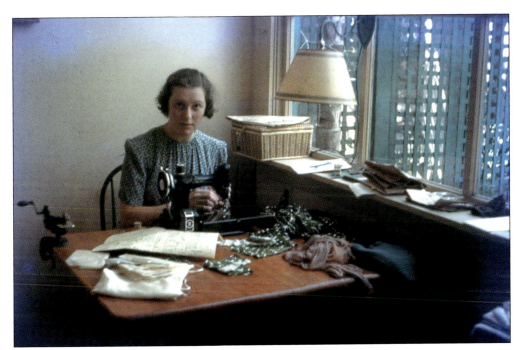

André Smith and the Bancas lived in separate quarters from the artists, maintaining a small home off the Main Garden. Smith stayed in the main house, and Duke and Florence Banca's bedroom was adjoined by a small courtyard that was screened by a lattice to secure the family's privacy. Smith enjoyed his solitude, and Duke Banca often acted as the main point of contact for the artists. Florence tended to most of the household affairs and is pictured above in her office, which was in the main house. This space would later be converted into a bedroom for their son Peter Banca. Below is a mural and bench in the intimate courtyard shared by the family. The bench remains today, but the mural only survives in photographs.

Mary Bok continued to be an important figure in Smith's life. They forged a deep friendship during the planning of the Research Studio, and according to Peter Banca, Bok had fallen in love with Smith during the process. Banca recalls that Bok proposed to Smith at his Stony Creek home, but Smith turned down her proposal, feeling that he was not a complete man due to his amputation and fearing that he would be a burden on her. Smith also later confided to Duke Banca that he rejected Bok's proposal because he did not want to "wear a dinner coat in Philadelphia." The truth surrounding their relationship remains obscured by time and a decision the Bancas made after Smith's death to burn all of the letters between Smith and Bok out of respect for all parties. What is known for certain is that the two remained dear friends until the end of Smith's life, constantly writing and tenderly referring to each other as family. Pictured above are Bok and Smith in the Studio Court, and below is the interior of the Bok Studio.

A Sketch for "FOLKLORE VILLAGE Eatonville . Florida

Famed author and anthropologist Zora Neale Hurston, a native of nearby Eatonville, was another regular visitor to the Research Studio, being one of the few close friends that would be invited to join André Smith for tea in his studio. Their friendship endured through the end of Smith's life, with Peter Banca recalling that one of the last trips Smith took in the months before his death was to visit Hurston in a nursing home in Fort Pierce, Florida. A fascinating memento of their friendship (pictured above) is a sketch for a Folklore Village in Eatonville, Florida. The drawing shows a compound of small studios, courtyards, and an amphitheater, reminiscent of the Research Studio's winding design. Pictured at right is a photograph of Hurston by Carl Van Vechten. (Right, Library of Congress, Prints & Photographs Division, Carl Van Vechten Collection, LC-DIG-van-5a52142.)

In the early years of the Research Studio, the exclusive Laboratory Gallery could only be accessed by special invitation. In 1940, however, André Smith added an entrance to the gallery off Packwood Avenue, pictured above. Smith writes of his decision in the board minutes, "Originally our Gallery was intended primarily for the exhibition of work done by our artists while in residence. This failed because the artists as a whole did not produce enough work to warrant a showing except at the end of the season. For that reason we began 'importing' exhibitions and preferably ones that would illustrate the various trends in modern art. As our audience increased and our exhibitions between became more numerous it was evident that we needed not only more exhibition space but it became necessary to make the Gallery directly accessible from the street."

The new gallery entrance and welcoming atmosphere unsurprisingly resulted in an upswing in attendance, with Smith noting, "The attendance at these exhibitions was so good that it proved to us that the new street entrance had removed the feeling of exclusiveness and that our earlier shows were only for especially invited guests. Furthermore this evidence of our willingness to welcome the public has had a favorable reaction on our own townspeople and the town officials." Public attitudes toward the modern works being exhibited were also changing, with Smith remarking that a 1941 exhibition of works created at the Research Studio was exceptionally well received, whereas in the past, it would have been met with "open resentment." Pictured above is a close-up of the gallery door decorated with carved linoleum panels, and below is a view from the street into the gallery.

A major expansion to the Research Studio began in the summer of 1939, when land on the south side of Packwood Avenue was purchased to build a "playzone" for the artists. The new space, which can be seen in the illustration above (*The Research Studio*, 1939, watercolor on paper), included a badminton court, Ping-Pong room, and shuffleboard court. It was not long, however, before André Smith's plans for the space began to transform into something much grander, much as his original plans for a simple gallery had swelled into a visionary artist's community. In the spring of 1941, Smith began another round of construction on the playzone, intending to build a garden-chapel that he "had in mind for several years." Pictured below is a photograph of the construction in progress.

André Smith's Garden Chapel would become one of the most iconic manifestations of his unique architectural style, which has been classified as Mayan Revival but expands well beyond that definition. Smith's blend of Mesoamerican-inspired, Christian, and Buddhist imagery, combined with his dreamlike floral motifs, meld together to create a singular vision born from Smith's rich imagination. Unlike the main campus of the Research Studio, the structures of the roughly 5,000-square-foot Garden Chapel and Mayan Courtyard were not finished with stucco. Instead, the concrete was left bare to age and weather, like the mystical ruins in Smith's own fantasy works. The photograph above shows the Mayan Courtyard under construction, and the image below shows a work crew framing out the foundation.

The Garden Chapel and Mayan Courtyard make up one singular enclosure, but inside they are separated into two distinct areas by a central walkway. The Garden Chapel is adorned with Christian imagery, and the Mayan Courtyard contains a blend of Mesoamerican-inspired and fantasy imagery, giving the compound a distinctly dual nature. Along the walkway, there are panels that contain serene Christian saints on one side and a slate of passionate warriors on the other. When André Smith was asked by one of the artists why he chose to blend all of this seemingly disparate imagery in one place, Smith's reply was simple: "That's the way life really is." Pictured are exterior views of the compound that show this blend of motifs.

The construction of the Garden Chapel and Mayan Courtyard commenced under the shadow of World War II. Smith, a veteran, carved the following into a panel leading into the Garden Chapel (pictured above): "I stood at the gate of life and said / Give me a light that I may go safely / Into the unknown and a voice replied / Go out into the darkness and put / Your hand into the hand of God / That will be to you better than a / Light and safer than a known way." The phrase is from a radio address that King George VI of England broadcasted on Christmas of 1939, just at the onset of the war. Pictured below is a view from the center walkway looking toward the gallery.

André Smith's work in set design, which gave him an understanding of how to dramatically work with scale and depth, influenced much of the architecture at the Research Studio. In the Garden Chapel, one can see direct examples of this. The image above shows the Garden Chapel cross, a towering, multi-paneled sculpture flanked by walls unfolding toward the viewer. The image below, which bears a striking resemblance to this design, is an illustration from *The Scenewright*, a 1927 guide that Smith wrote on set design. The illustration pictures a series of posts and screens, which could be modified to create a variety of settings that were "suggestive of interiors as well as exteriors." The Garden Chapel maintains this feeling of simultaneously being both inside and outside.

RESEARCH STUDIO, MAITLAND, FLA.

It is believed that the Garden Chapel was built to honor André Smith's mother. The walls of the intimate enclosure are decorated with sixteen panels that depict the life of Christ, along with eight additional reliefs of saints that were done by artist Clifton Adams. This postcard also shows a row of statues depicting the Apostles, which originally stood on top of the chapel columns. After Smith's death, all but one of the six statues were removed or destroyed. It is the hope of the center that they will one day be found and returned so that the chapel can be fully restored.

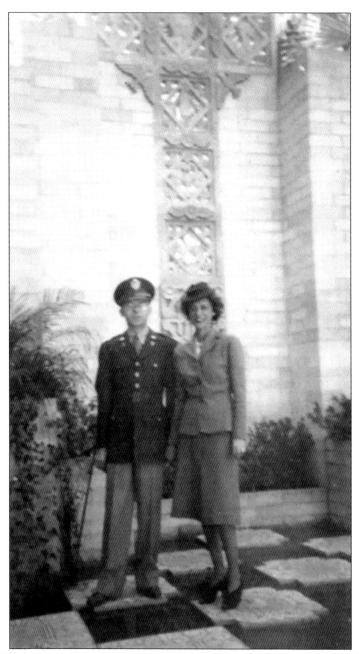

The Garden Chapel quickly drew visitors to the site, and by 1948, the center had hosted three weddings in the space. The popularity of the chapel has endured over the years, with numerous couples annually exchanging their vows in the serene setting. Perhaps André Smith foresaw this when he inscribed at the entrance to the chapel, "Let your thoughts rest here awhile in beauty and in love." The photograph above shows Dr. George "Fritz" Crisler and his new wife, Jane McCartney, in 1943. Dr. Crisler was André Smith's doctor as well as his close friend and would serve on the Research Studio's board of directors after Smith's passing. He and his wife were married at the site, and in the photograph, they are standing on carved stepping stones in a small pool in front of the cross. (Courtesy of Jeni Bassett Leemis.)

André Smith, a believer in the sanctity of all world religions, was himself a devout Episcopalian. His leg made it difficult for him to physically attend church, but Florence Banca recalled in a 1991 interview that after the chapel was built, Smith would often visit the space before breakfast with his prayer book in hand. The space was referred to as the "Chapel of St. Francis," a reference to the relief of St. Francis adjacent to the chapel alcove. Above is a photograph of the relief with its original color intact. Like the rest of the center, much of the Garden Chapel and Mayan Courtyard was vividly painted during Smith's time. Pictured below is artist John Hawkins seated in the chapel.

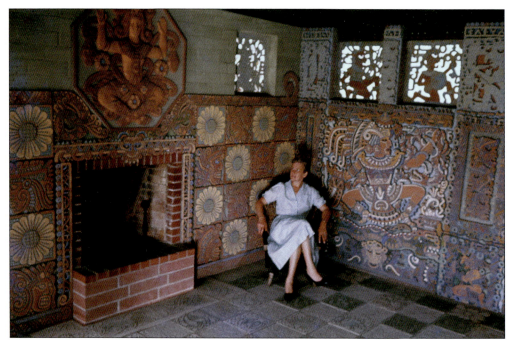

The 18-foot mural in the Mayan Loggia is one of the most ambitious artworks at the site. The piece was created by John Hawkins, who was a Bok Fellow artist during the 1940–1941 season. At the end of the season, Hawkins requested permission to stay at the site during the summer and paint a mural in the newly created loggia. André Smith, who had returned to Connecticut for the summer, agreed, but on the condition that Hawkins first send a sketch of the project. The summer passed without any word from Hawkins, and when Smith and the Bancas returned to Florida, they discovered that the entire concrete mural had been created. Fortunately, Smith was impressed with the piece, finding it to be an "exceptional performance." Florence Banca noted later, however, that "all hell would have broken loose, I think, had he not liked it." Smith and Hawkins painted the concrete mural together. Pictured above is Florence Banca in the Mayan Loggia, and below is a contemporary view of the mural (Below, photograph by Danielle Thomas.)

André Smith frequently encouraged the resident artists to experiment with concrete sculpture, and John Hawkins and Clifton Adams were not the only artists to contribute artwork to the site. Bill McVey, who was a resident artist during the 1939–1940 season, created the sculpture pictured at right, which sat at the end of the lattice-covered walkway that led to the Mayan Courtyard. Below is a circular Madonna sculpture created by Wilma Wolfs, who was a resident artist during the 1940–1941 season. This piece is the only sculpture at the site known to have been created by a female artist. Like Hawkins, Wilma Wolfs had also stayed at the site during the summer to do commission work, creating a grave marker for the prominent Bumby family.

The United States' entry into World War II caused the Research Studio's fifth season to slowly unravel. Three of the artists left early due to the war, and John Hawkins, who had contributed the expansive mural in the Mayan Loggia, left early due to an outburst over works he wanted to include in an exhibition that Smith felt "might prove offensive for public display." This left only Clifton Adams, who continued to work with Smith on the Garden Chapel through the end of the season. The war forced Smith to suspend the residency program in 1943 and 1944. He continued his sculptural work and held exhibitions in the gallery, however, visitation slowed to a trickle due to gas and rubber shortages. In the board minutes from this period, he wrote, "Whereas in former years between 100 and 150 would come on the opening day, this time there was but one single visitor, a brave woman who came on a bicycle from Winter Park." Pictured is the decorated north wall of the Mayan Courtyard.

André Smith, a veteran and a patriot, hoped to aid war efforts by offering the Research Studio for camouflage work. He wrote to Lt. Col. Homer Saint-Gaudens, who was Smith's commanding officer in the Camouflage Corps, "Our gallery building might serve as an office and also for the display of illustrative models or other instructive displays. And inasmuch as we are discontinuing our fellowships to young artists for the duration of the war, five or six combination studios and bedrooms would be available in addition to work rooms. . . . In fact we could put our whole establishment to some useful purpose and in it include myself and my very helpful friend and companion Attilio Banca." Smith was not taken up on his offer but did provide housing to at least one interesting guest in this period: the American author Winston Churchill, a friend of Smith's, who stayed at the site with his wife and son to write his last book, *The Uncharted Way.* Pictured above is sculptural work in the Mayan Courtyard, and below is a 10-foot-tall sculpture on the exterior wall of the compound.

As the United States emerged from World War II into a period of prosperity, Smith also entered a robustly productive phase in his artistic career. In 1946, he produced a large number of oil paintings, which he describes in a manifesto: "These new paintings of mine . . . can best be classified under the heading of 'Magic-Realism.' According to the authoritative curator of the Modern Museum in New York, Mr. Alfred Barr Jr., Magic-Realism is defined as 'A term applied to the work of painters who by means of an exact realistic technique try to make plausible and convincing their improbable dream-like or fantastic visions.'. . . I offer them not as finished paintings, but merely as a further experiment in my effort to record these visions of the 'inner-eye' in contrast with the matter of fact of the 'outer-eye.' It might be called the difference between a spiritual insight in contrast with the ordinary, or material way of seeing things." Pictured above is *Untitled (Masks and Throne)*, 1946, oil on board.

The work that André Smith created during this period was done under the looming shadow of the atomic age, which would press its fingerprints upon the imaginations of a generation of artists. In January 1946, Smith hosted a lecture by Dr. Karel Huyer on "The Philosophic Implications of the Atomic Age" before an audience of 45 invited guests, and in same month, Smith wrote in a review of an exhibition of Spanish works shown at the Morse Museum, "I rather hoped that the first new year of the Atomic Age would bring to Florida, in its art offerings at least, a realization that we are living in a new world, one in which anything can happen, that youth, freed from the restrictions of war service, was again in the saddle riding to unlimited heights or utter destruction, but at least in full and fearless forwardness." Pictured here is *Untitled (Fireplace)*, 1946, oil on board.

André Smith's new artworks were shown in the Laboratory Gallery in the spring of 1947. A review of the show in the *Winter Park Topics* noted, "The exhibition . . . is much more than an art show. If those who assert their abhorrence of modernism and especially of surrealism were to expose themselves to them—with no one looking—they might find that there is something impressively intriguing in these strange pictures. They might even repeat the experience of the uncompromising elderly visitor who berated Mr. Banca, Mr. Smith's assistant, for abusing her patience by showing her such outrageous pictures,—then later, after some detail had caught her attention, reconsidered, and later offered her apologies for being abusive herself. She had unknowingly opened some one of her conventional barriers to this kind of art and became susceptible to new conceptions." Pictured above is *Flight to Egypt*, undated, oil on board, and below is *Untitled (Many Heads)*, 1946, oil on board.

The review of the show continues, "I found a young Rollins student deeply absorbed and thought he would give me some helpful ideas,—the younger people don't damn things because they are strange. We looked at some of the surrealist pictures together and each commented according to his own light,—a good way to enjoy an art show,—and after trying to fathom the meaning of them I asked him 'Is it art, or is it psychology cleverly illustrated?' " He answered well to the point: "These pictures are just as important art as the old conventional kind,— they tell the truth about life." Pictured above is *Untitled (Naked Card Shark)*, 1946, oil on board. Pictured below is *Untitled (Surreal Yard Sale)*, 1946, oil on board.

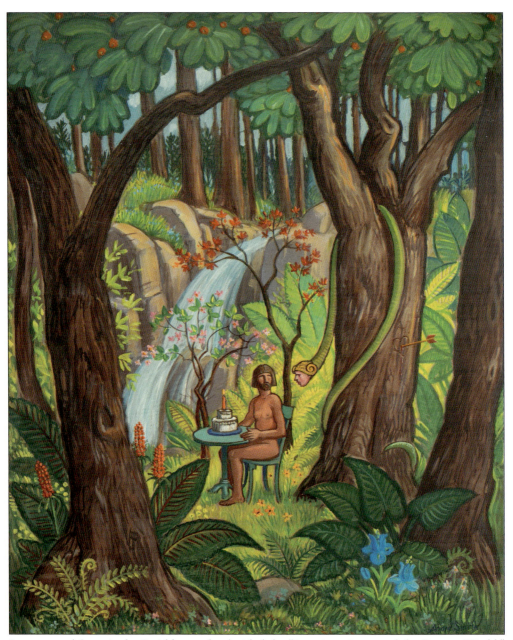

In a postcard from André Smith's scrapbook titled the "American Artist and the Postwar World," Smith elaborates on the role of the artist in a postwar world: "Art today is at a boiling point, and so is the world. One cannot indulge in an orgy of war and destruction, hatred and suspicion, and expect an aftermath of serenity. Nor can one expect our artists, many of whom have but a short time ago put aside their hot rifles, to picture something that is no longer there. It is only the hobby-painter who can today make a picnic of art. He can sit in a cow pasture and paint buttercups and daisies; but he is lucky to get back home without having been lifted over the meadow fence by some critical bull who knows nothing about art. The truth is that no one can sit on the horns of a dilemma and paint pretty pictures." Smith concludes with, "The Bells of Destiny are now playing jazz." Pictured above is *The Uninvited Guest*, 1946, oil on board.

An influx of visitors was coming to see the Research Studio exhibitions, and in 1947, André Smith began closing the center on Mondays to provide time to recover from the traffic. In an article announcing the new gallery hours, Smith again underscores the experimental nature of the work done at the center, writing, "Our exhibitions stress as far as possible the present-day trends in art, or any work that is of an experimental nature that may point a new path that will lead to the art of tomorrow . . . we try to make clear the nature of the exhibitions that we are showing. We do not have to resort to comic methods of subconscious, psychological or astrological ballyhooing and clowning in order to attract people to our exhibitions; nor do we give little gallery chats for the same purpose. People who come to our exhibitions either like them or they don't like them; and that is all there is to it." Pictured above is *Untitled (Tower)*, 1946, oil on board.

André Smith made several changes to the residency program at the Research Studio in the postwar years. The studios, which originally housed five artists, were converted into individual apartments, with a studio, kitchenette, bedroom, and bath. Artists were now responsible for providing their own meals, and beginning in 1946, Smith also began charging a nominal rental fee for the space. He writes in the board minutes of the change, "Our experience with rent-free studios . . . has shown by experience that the idea of what we have called 'the handout system' has resulted in greater demands from visiting artists and which in turn, upon our refusal to give more, has resulted in criticism and discontent." After changing over to the new system, Smith notes that it has led to an "especially happy relationship with the artists." Smith continued to expand the center during this period, most notably with a small sculpture gallery, pictured above, adjoining the Mayan Loggia. Smith's sculptures and "concrete paintings" can be seen in both photographs.

In 1950, André Smith built a new studio to house his personal library, adjacent to his own workspace. A courtyard adjoining the library was also added and is unique in that it contains Buddhist imagery, perhaps inspired by Smith's childhood in Hong Kong. Pictured above is the original wooden gate leading into the courtyard walkway. The door was originally painted with a bright mural depicting a grove worker but was later replaced with a metalwork gate with a sunflower motif. This photograph is one of the few remaining images of the original gate that has survived. The image below shows the courtyard, with the Buddhist medallion on the south wall.

André Smith remained reclusive in his older years, with the newly built courtyard and library affording him even more privacy. Only Smith's closest friends would be invited to join him for tea, including Gino Perera, Dr. Fritz Crisler, Donald Barker, and Zora Neale Hurston. Peter Banca humorously recalls that Smith was notorious for his reluctance to socialize, noting, "You came to visit him, and eventually you were dismissed." Despite his private nature, Smith still liked to be kept informed about what was happening on the rest of the grounds, particularly in the gallery. Florence Banca recalled in a 1991 interview that Smith would have Duke Banca visit his studio and recount word by word what people thought of the exhibitions. Pictured above is a view of the courtyard showing a delicate screen on the west wall looking out at Lake Sybelia, and at left is André Smith.

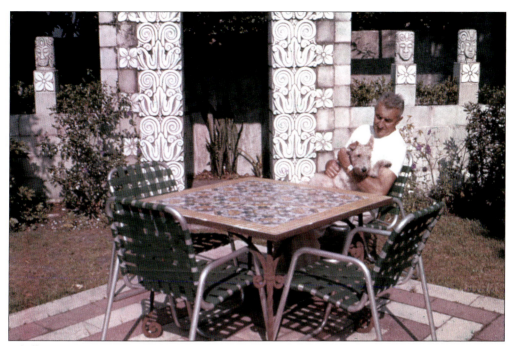

A bell tower with an intricate pattern of floral motifs was built in 1950, separating the Main Garden from André Smith's studio and library. The bell that was originally in the Studio Court was moved to the new location, and Smith would ring the bell when he needed Duke or Florence Banca, with the number of rings indicating which one should come. The Banca family also grew during this period, with Peter André Banca being born in 1948. Pictured above is Duke Banca with their wire-haired fox terrier Pab, named after Peter Banca's initials. Peter Banca recalls that Pab would stay with Smith while he was at school, going for car rides, visiting the chapel, and napping with Smith every day after lunch. Pictured at right is a view of the bell tower.

The Research Studio flourished during the 1950s, but André Smith found that the new paid-studio structure changed his role with the artists. In the 1951 board minutes, he wrote, "Our resident artists have on the whole conformed to the trend of modern art. But with the advent of older and more established artists my position as Director is limited entirely to the matter of managing the Research Studio rather than being of help to them by way of criticism or advice. This I was able to do with our younger artists and it resulted in experimental work that under the present situation is no longer possible." Pictured above are, from left to right, Milton and Sally Avery with Wallace Putnam during the 1950–1951 season. Below is a sketch from Smith's scrapbook showing the "The RS Zoo," with cartoons of Consuela Kanaga, Wallace Putnam, Milton Avery, and Sally Avery.

The colorful rotation of artists and guests at the Research Studio often raised eyebrows in the surrounding communities. Artist Larry Loessing recalled that "many of the artists wore beards which were not in style at the time so local residents thought the Research Studio was an unusual place." André Smith's strict policy of ensuring the artists' privacy would have contributed to this perception. Peter Banca described an instance where this misunderstanding led to an unusual encounter. Pilots from the nearby military base flying over the site once spotted the Research Studio flag unfurled high above the grounds. Believing that the "RS" on the flag stood for "Russian Soviet," officials came out to the center, suspicious of communist activity. Banca noted that the visitors were embarrassed by their assumptions when they discovered that André Smith was a disabled World War I veteran. The image above shows one of Smith's abstract works from this era (*Untitled*, undated, oil on board), and the image below shows the Research Studio flag.

In 1952, André Smith suggested to Mary Bok that the name of the Research Studio be changed to the Art Center, and she readily concurred, "As to the Art Center, I think it an excellent term since the Gallery, the Studios, the Courts, and above all the Chapel do make up an actual whole Center—something more than a studio in which Research is made." This same year, Smith expanded the site again, this time adding an outdoor gallery adjacent to the Mayan Loggia as another space where he could display his "concrete paintings." The image above shows Ralph Ponder installing floor tiles in the new gallery. Ponder worked at the site for over 20 years and frequently assisted Smith with his concrete work. The image at left shows a young Peter Banca in the new space with Smith's paintings hanging behind him.

Despite André Smith's reclusive nature, he remained a vital figure in the local arts scene through the end of his life. A 1953 article in the *Winter Park Topics* perfectly summarized his personality and influence: "Long a figure of controversy, the artist remains aloof, calm and unflurried by all the fuss and criticism, perennially performing new spadework in the history of art in Florida. The Research Studio Gallery has a personality as intriguing and pungent as Mr. Smith's own sparkling comment and wit. A Cornell graduate in architecture and one of the nation's foremost etchers, he wages his war for new trends in modern art through many mediums such as raw cement, paper, and metal, and not least, a facile and provocative pen." Pictured above is a courtyard screen adjacent to the outdoor gallery, one of the last expansion projects that Smith would undertake. At right is a photograph of Smith with his dear friend and companion Duke Banca.

André Smith passed away at the Research Studio on March 3, 1959, at the age of 78, with Duke and Florence Banca at his side. His life was shaped by his uncompromising commitment to creativity and beauty. In a letter to Mary Bok in the later years of his life, he wrote, "I send you my usual overflowing helping of love. That hour of sunshine talk was only the top layer of a full heart of the deeper thoughts for which the words 'appreciation' and 'gratitude' are utterly futile." The same sentiment might be given to Smith, whose legacy enriches all today. Pictured above is Smith at his easel, a place where he was undoubtedly at his happiest. Below is a photograph of his studio after his death, with his last unfinished artwork.

Four

THE LIVING SITE

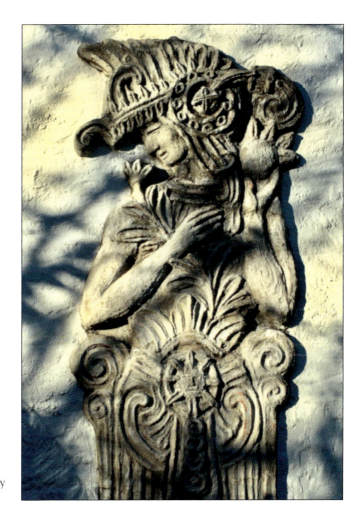

The Research Studio, now known as the Maitland Art Center, operates today in the spirit in which André Smith established it: as an artists' community, with artists still creating and experimenting on the grounds. It is a place where the creative spirits of the past mingle with today's brightest artistic minds and where all lovers of beauty may find sanctuary in Smith's utopian vision. (Photograph by Dan Hess.)

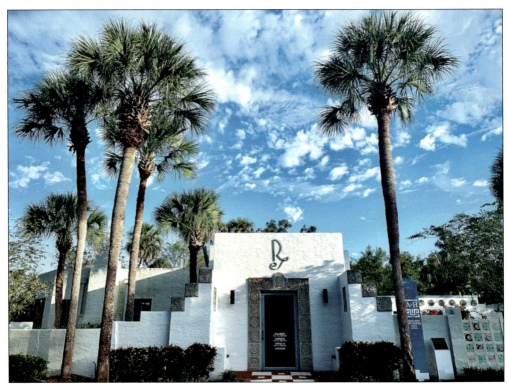

After André Smith's death, the center entered a period of uncertainty. The Bancas called Mary Bok shortly after Smith's passing, and she encouraged them to make a new life for themselves, telling them that the Research Studio had been "her gift of love to André," and now that he was gone, so was her interest in it. She funded operation costs for one more year and then resigned from the board, leaving Duke and Florence Banca, along with their friends Dr. Fritz Crisler and Donald Barker, to operate the center. Ultimately, they made the decision to sell the center to the Central Florida Museum, but this arrangement was also fraught with difficulty. A ruling by the Circuit Court of Orange County finally put the center into a public trust and sold it to the City of Maitland so that it could be preserved for all future generations, officially becoming the Maitland Art Center. Pictured above is the exterior of the gallery today, and below is a view of the gallery entrance from the Garden Chapel and Mayan Courtyard walkway. (Above, photograph by Dan Hess; below, photograph by Jim Hobart/Macbeth Studio.)

In 2010, the Maitland Art Center merged with the Maitland Historical Society to form the present-day organization of the Art & History Museums of Maitland. The center, which includes a gallery, history museums, and a thriving art school, continues to honor André Smith's legacy through its artist residency programs. The Maitland Art Center was designated as a National Historic Landmark in 2014, a prestigious recognition given to sites that represent an "outstanding aspect of American history and culture." The site received the designation due to its rich history and distinctive architecture. The Maitland Art Center is further unique in that the architectural ornamentation is comprised entirely of hand-carved artworks and original murals, making the entire complex an outdoor gallery of André Smith's artwork. Pictured above is the Main Garden gate, which had its original color restored in 2022, and below is a view of the Main Garden. (Above, photograph by Danielle Thomas; below, photograph by Daniela Ortiz.)

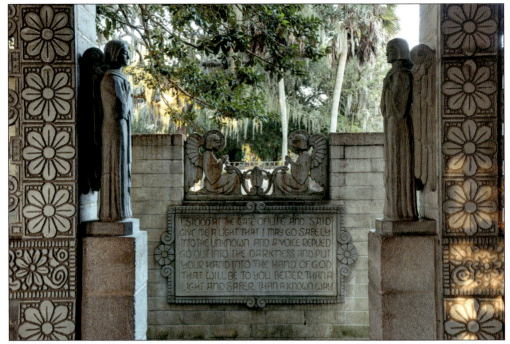

Today, André Smith's creative energy seems to remain as an invisible presence at the Maitland Art Center. In describing this feeling, local writer Robert Eginton once wrote, "There are times when you can almost see the Old Mystic—stocky, one-legged, wobbling slightly on his crutches, his hooked face like that of an old and indomitable hawk—his eyes fastened on something beyond you and me, some ineffable vision of might-be. His aura is restless, intractable, searching, forever railing against setting any limits for the creative spirit of mankind." Pictured above is a view from the Garden Chapel alcove, and below is the West Garden, flanked by wildflowers blooming in the fertile soil of the Maitland Art Center grounds. (Above, photograph by Jim Hobart/Macbeth Studio; below, photograph by Roberto Gonzalez.)

BIBLIOGRAPHY

The Art & History Museums of Maitland houses André Smith's archives, which includes his personal letters and interviews with residents of the site as well as the largest collection of Smith's artwork. Other sources include:

Bok, M. (1936-1953). *Correspondence*. Curtis Institute of Music Archives, Philadelphia, PA, United States.

Cornebise, Alfred E. *Art from the trenches: America's uniformed artists in World War I*. College Station, TX: Texas A&M University Press, 2014.

Denker, Eric. *Two for the Road: Ernest Roth and André Smith in Europe, 1912–30*. Carlisle, PA: The Trout Gallery, the Art Museum of Dickinson College, 2022.

Eginton, R. "An Environment for Art." *Central Scene: The Magazine of Florida's Good Life*. April/May 1974: 36-69.

Krass, Peter. *Portrait of War: The U.S. Army's First Combat Artists and the Doughboy's Experience in WWI*. Hoboken, NJ: Wiley, 2007.

Kunerth, J. "The Once and Future Dream of Andre Smith." *Orlando Sentinel Florida Magazine*. April 3, 1983: 13-14.

O'Gorman, James F. *Aspects of American Printmaking 1800-1950*. Syracuse, NY: Syracuse University Press, 1988.

stars.library.ucf.edu

Smith, André. "An Insanitorium of Art." *Art Instruction*. November 1939.

——. *Art and the Subconscious*. Maitland, FL: the Research Studio, 1937.

——. "Two Parts Sand —One Cement." *American Artist*. September 1940.

Smith, J. André. *In France with the Expeditionary Forces*. New York: Arthur H. Hahlo & Co., 1919.

——. *The Scenewright*. New York: the Macmillan Company, 1926.

Tolerton, H.H. *Illustrated Catalogue of Etching by American Artists*. Chicago: Albert Roullier Art Galleries, 1913.

Winter Park Topics, 1935-1955

DISCOVER THOUSANDS OF LOCAL HISTORY BOOKS FEATURING MILLIONS OF VINTAGE IMAGES

Arcadia Publishing, the leading local history publisher in the United States, is committed to making history accessible and meaningful through publishing books that celebrate and preserve the heritage of America's people and places.

Find more books like this at
www.arcadiapublishing.com

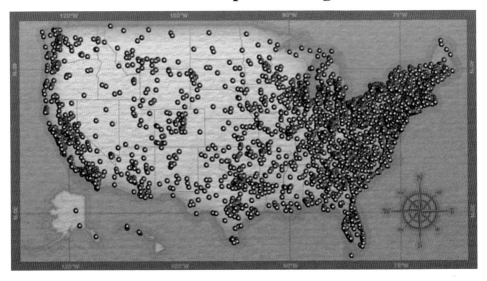

Search for your hometown history, your old
stomping grounds, and even your favorite sports team.